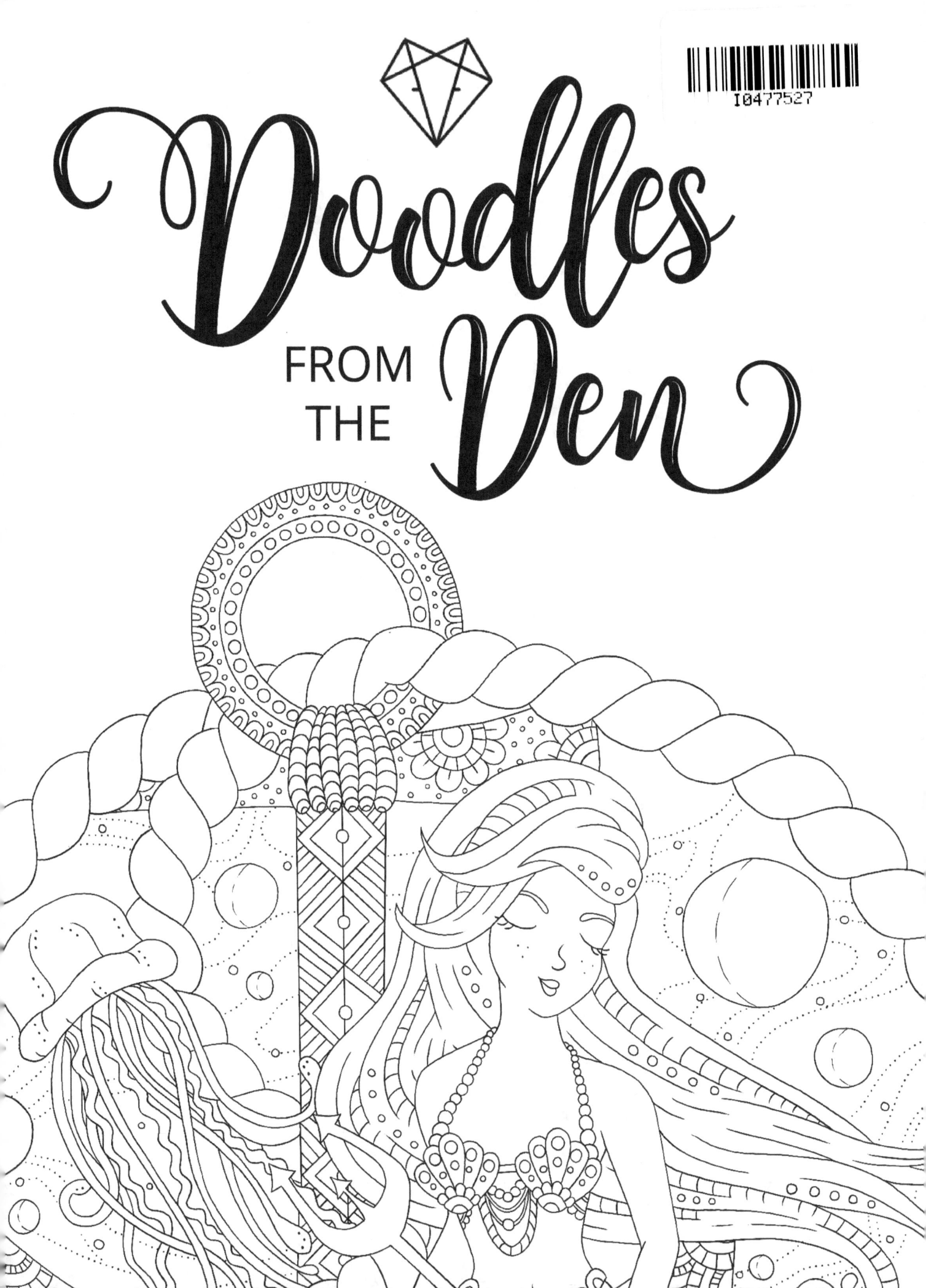

Copyright © 2017 by Kim White. Fox Design Den.

All rights reserved. This book or any portion thereof
may not be repoduced or used in any manner whatsoever
without the express written permission of the author.

ISBN-13: 978-1981130986
ISBN-10: 1981130985

www.foxdesignden.com

Hello, you

I'm so humbled that my book has found it's way into your creative hands – I can tell this is going to be the start of a magical, colourful adventure.

Over the pages that follow, I invite you to explore your inner artist, and to add your personal touch to the cute and quirky designs I've doodled for your enjoyment.

From mermaids to sea monsters, I hope you'll discover something that satisfies your colouring sweet tooth.

Useful tips

- At the back of this book, you'll find a dedicated 'Test your tools' page, perfect for trying out colours, blends and testing felt tip pens

- If you're using alcohol-based markers, pop a sheet of scrap paper beneath the page you're colouring to avoid bleed through on to the following design

- When working with pencils, build up colour by using a gentle pencil pressure and layering gradually – and remember to keep those pencils sharpened to help stay inside the lines and combat those intricate details

- Stuck for colour combinations? Get a little dose of inspiration at **www.coolors.co** or try challenging yourself to use colours you wouldn't typically pick

- Colouring is meant to be fun, so don't feel like you need to stick to the rules! Use colours that inspire you, and if you find yourself getting frustrated, put the book aside and pick it back up when you're ready to dive back in again

- Ready to show off your masterpiece? Remember to use **#FoxDesignDen** on social media so I can find your work – I can't wait to see my doodles brought to life!

Join my colouring group

I've created a dedicated, private Facebook group for you to share your colouring creations from this book. Simply follow this link to join: **www.facebook.com/groups/thecolouringden**

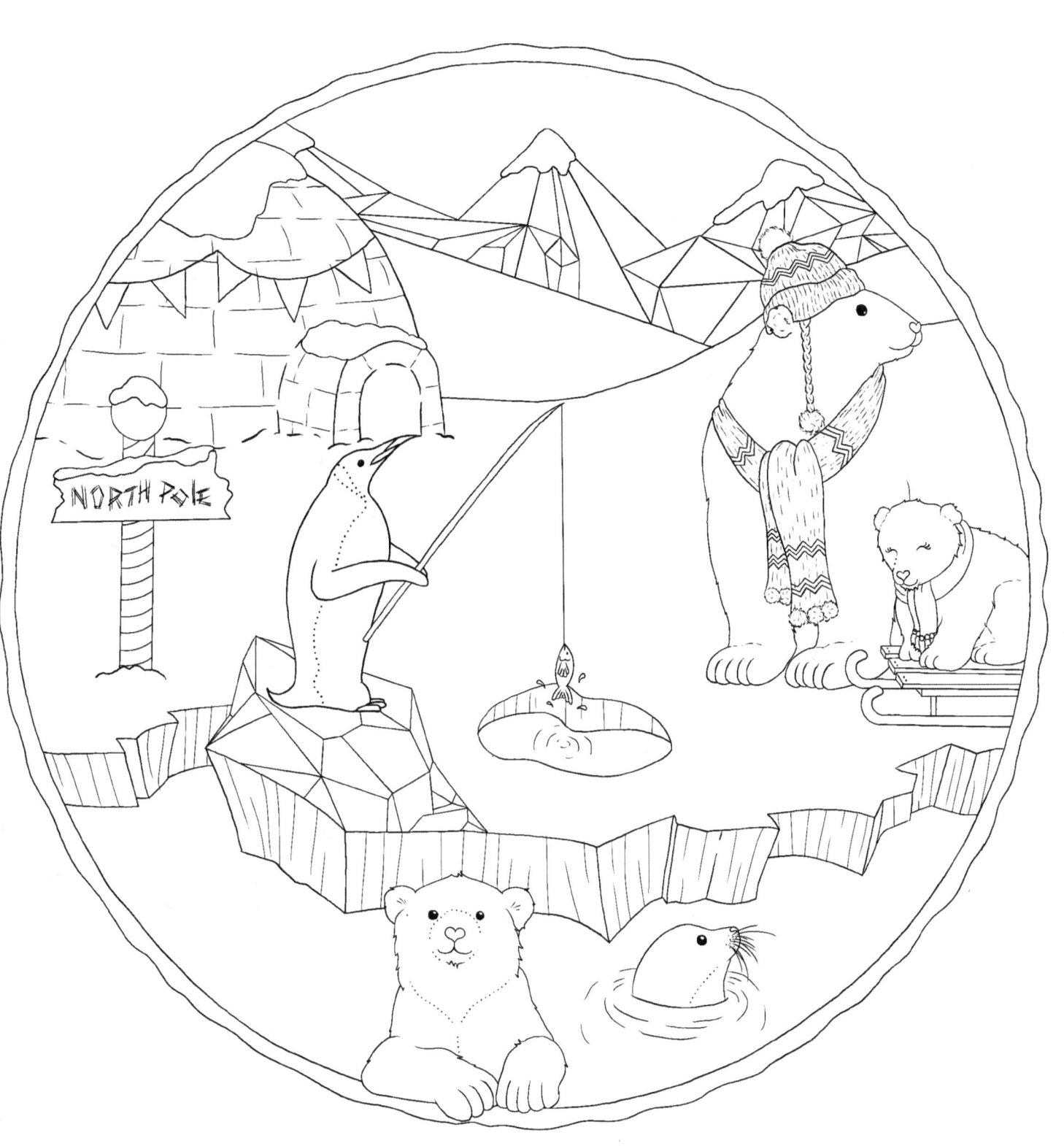

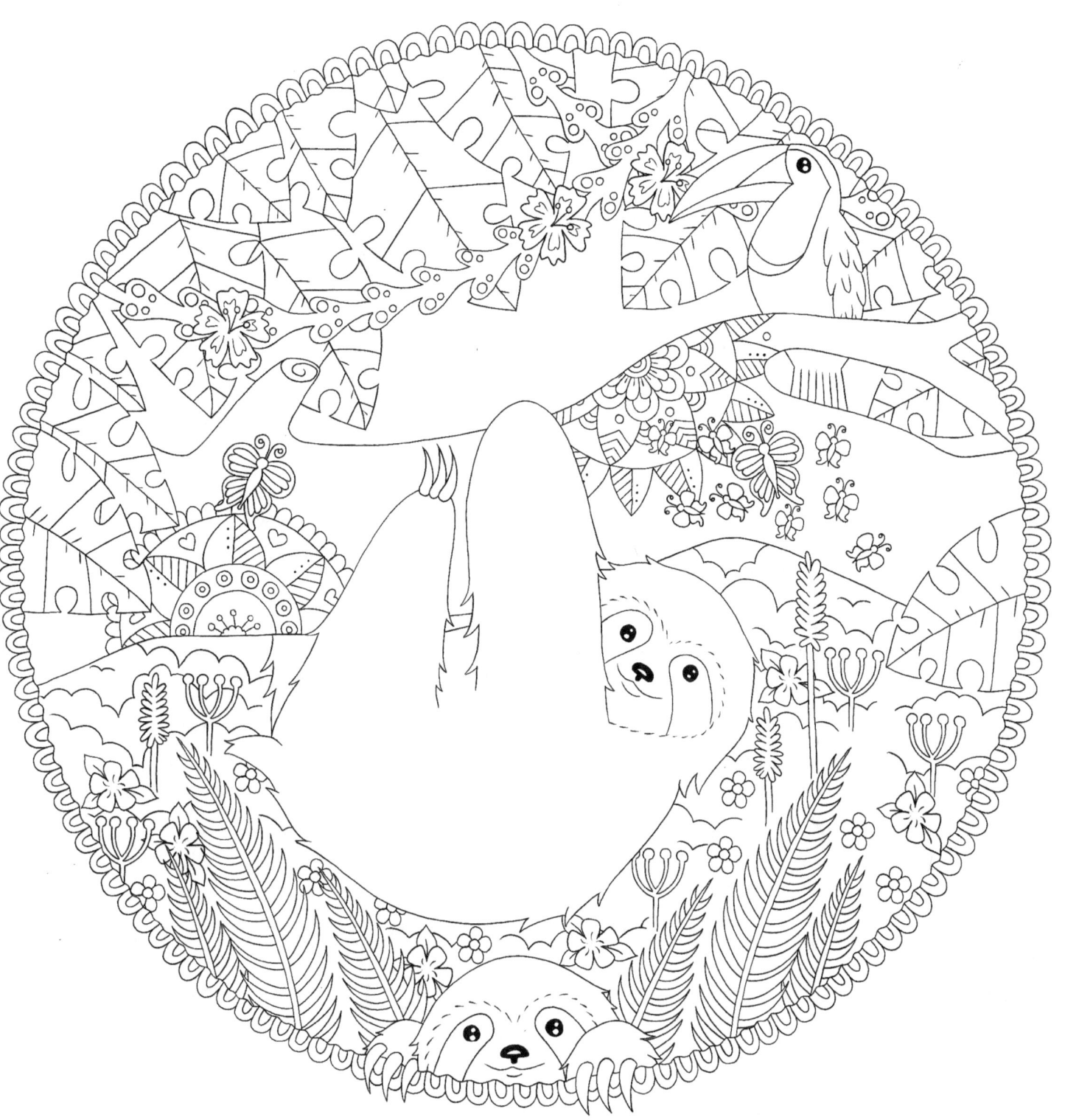

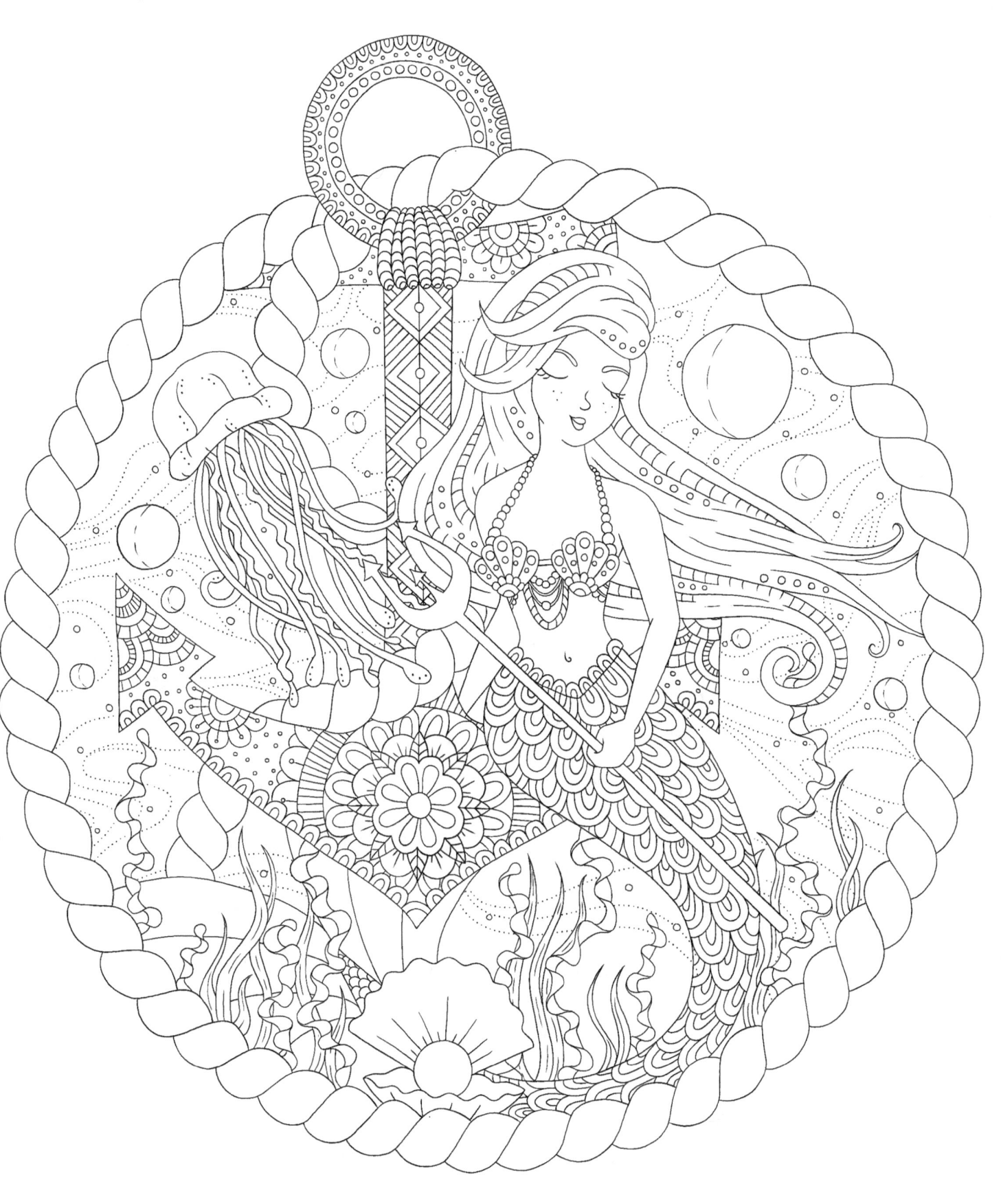

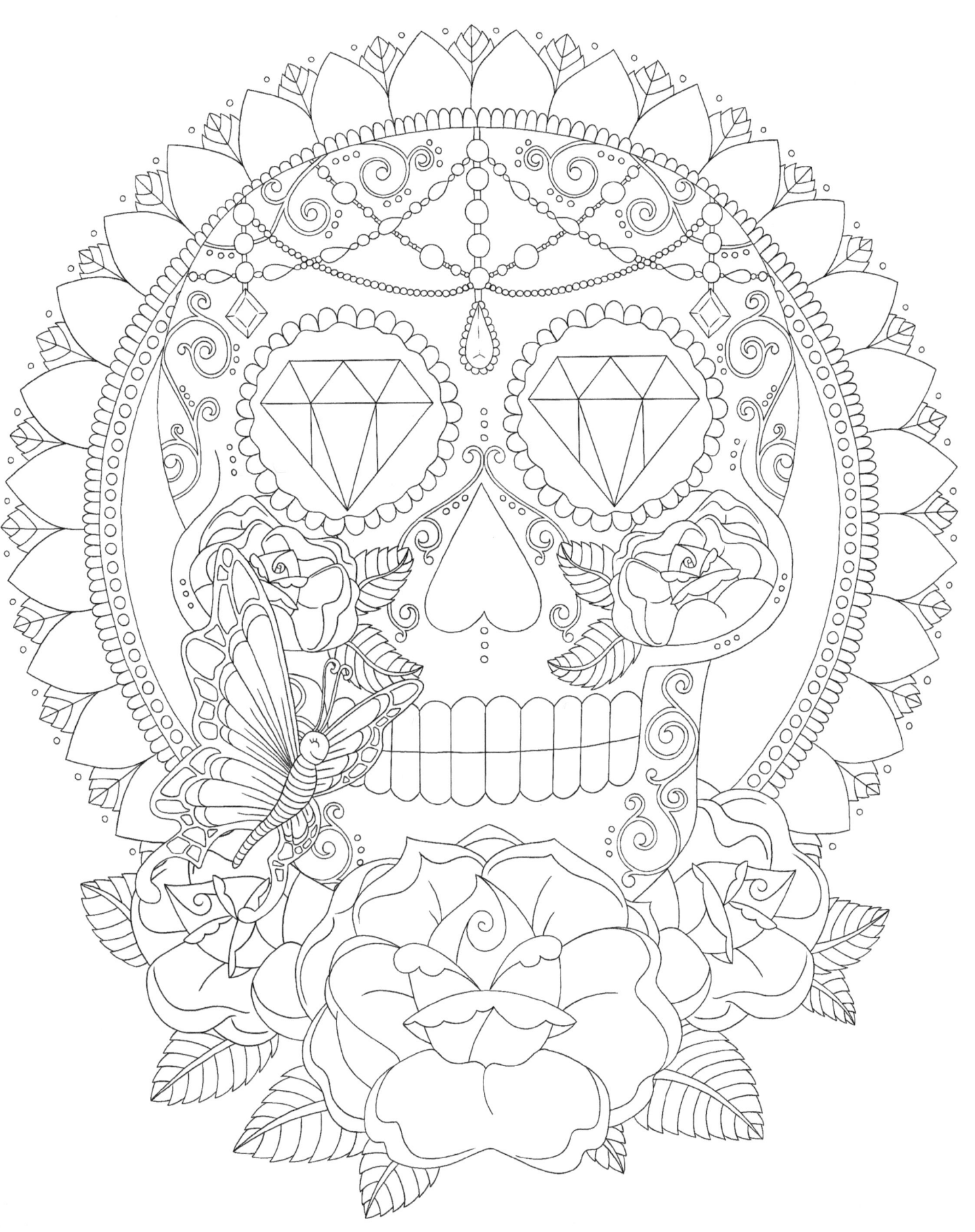

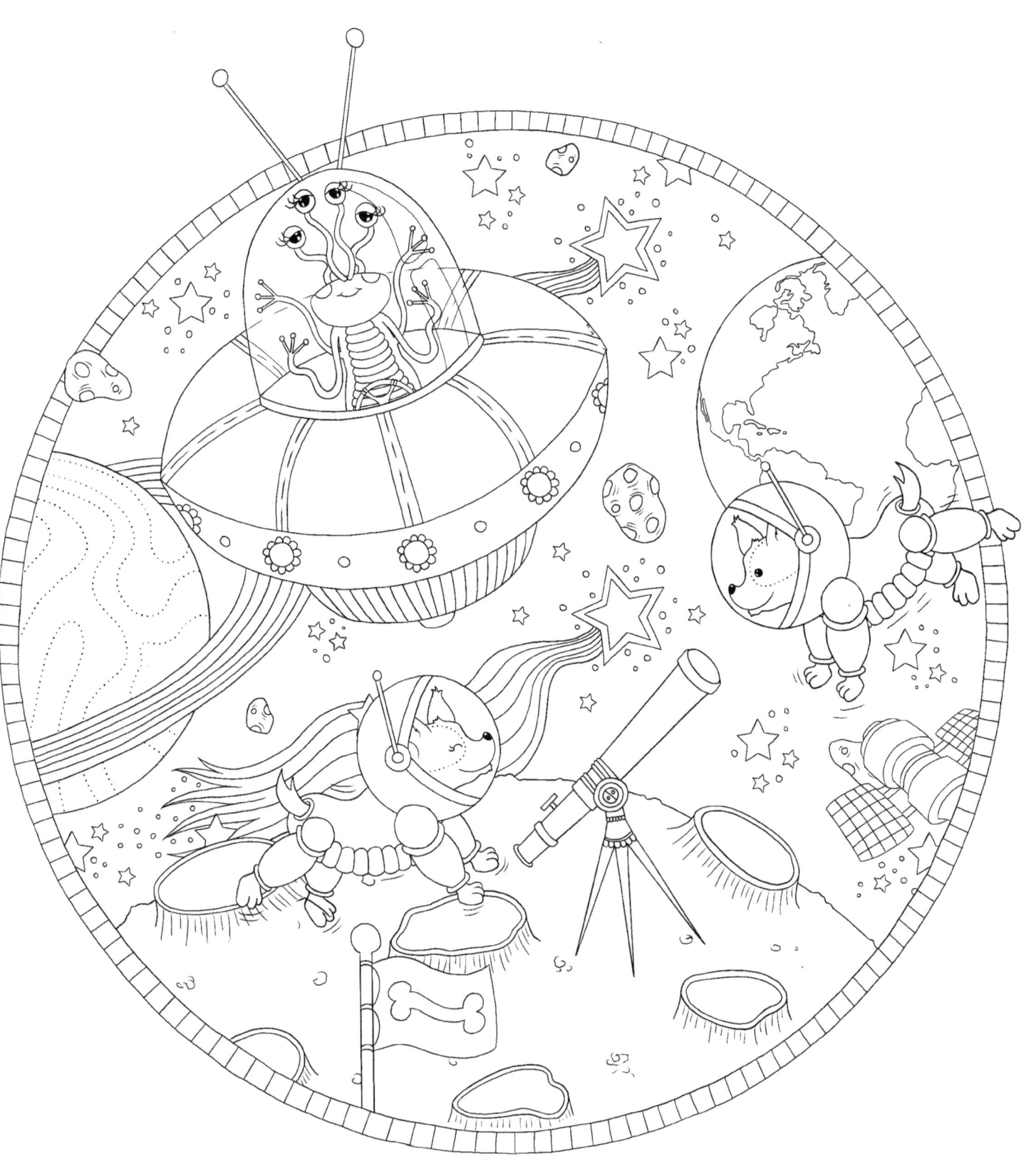

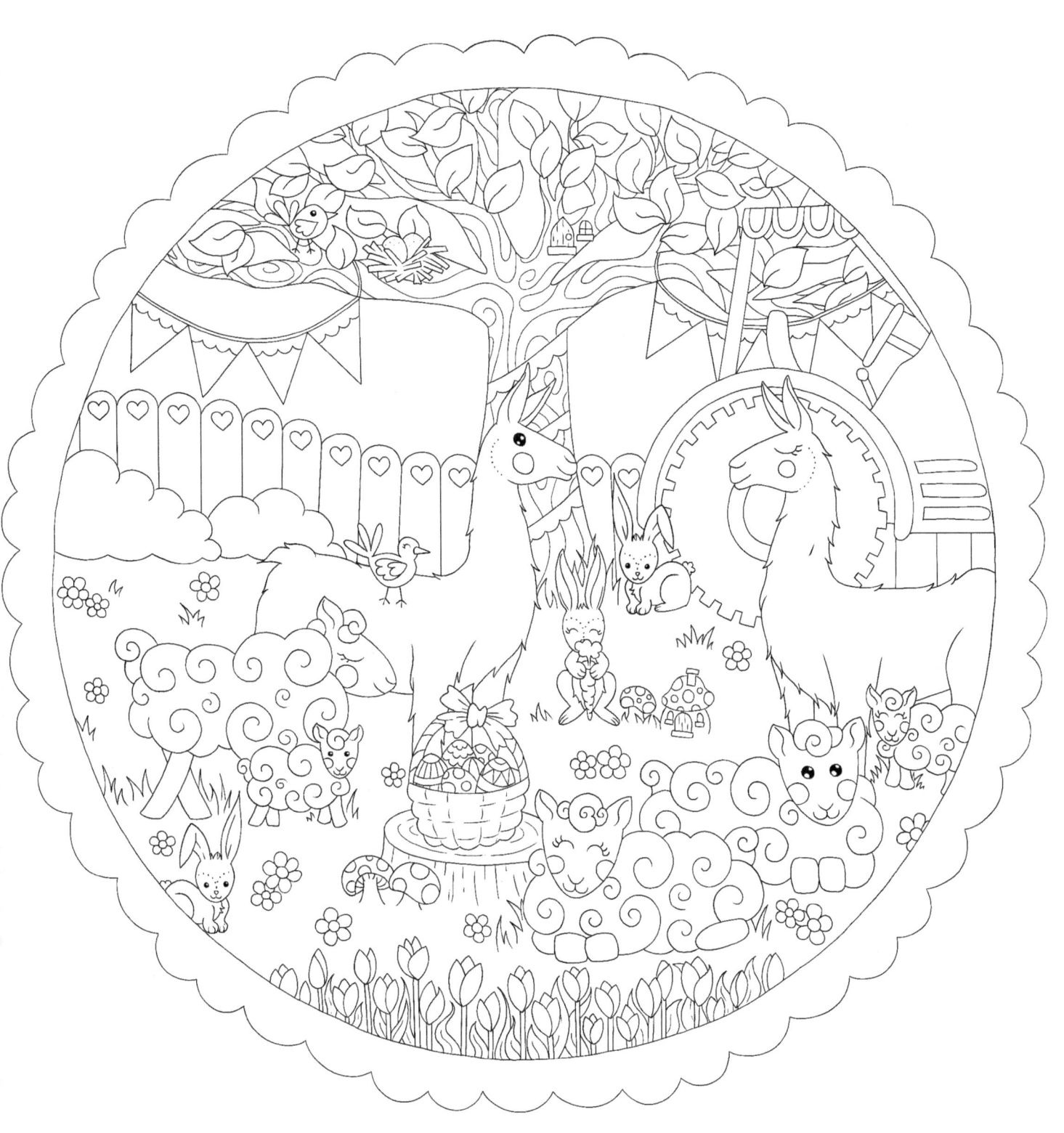

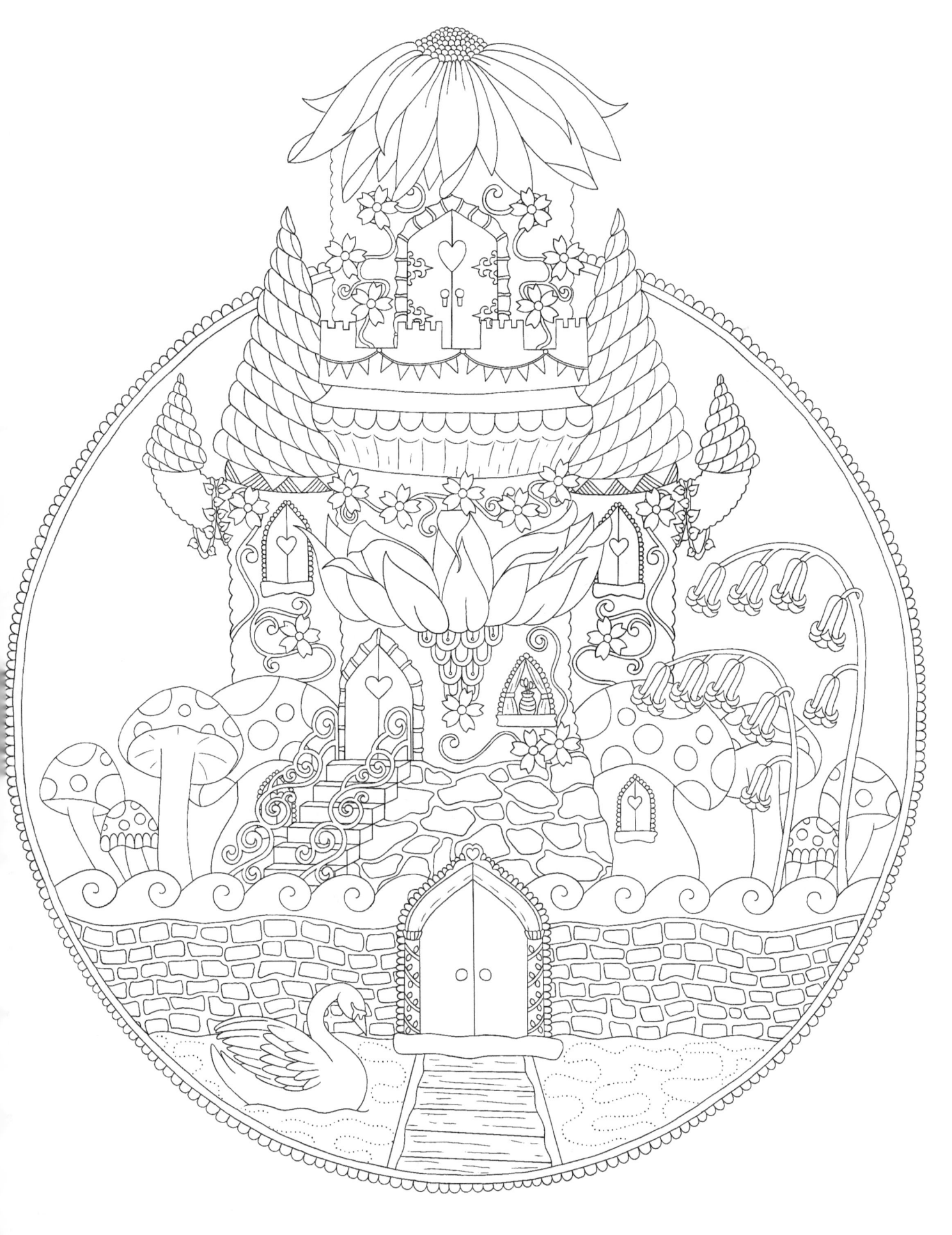

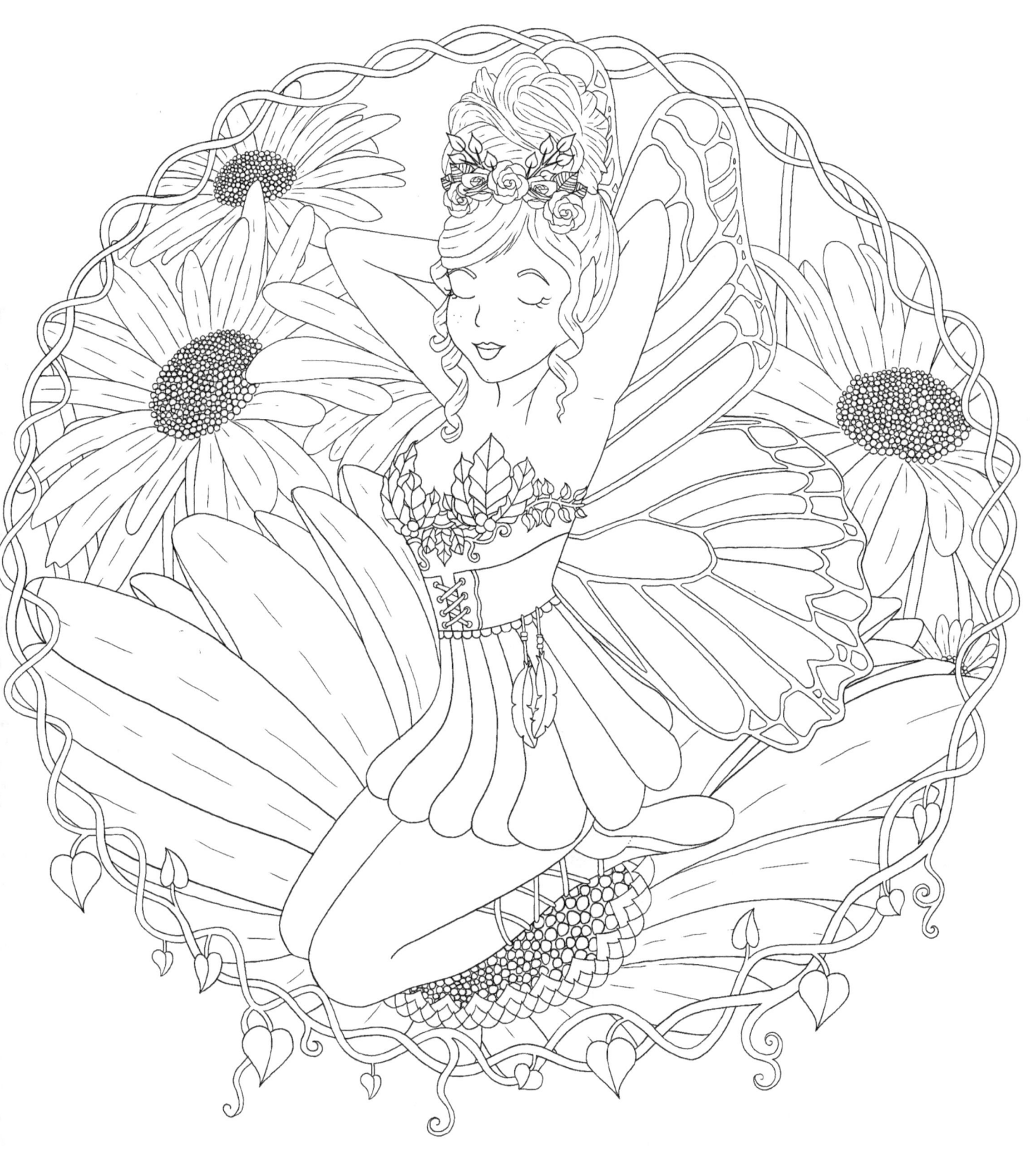

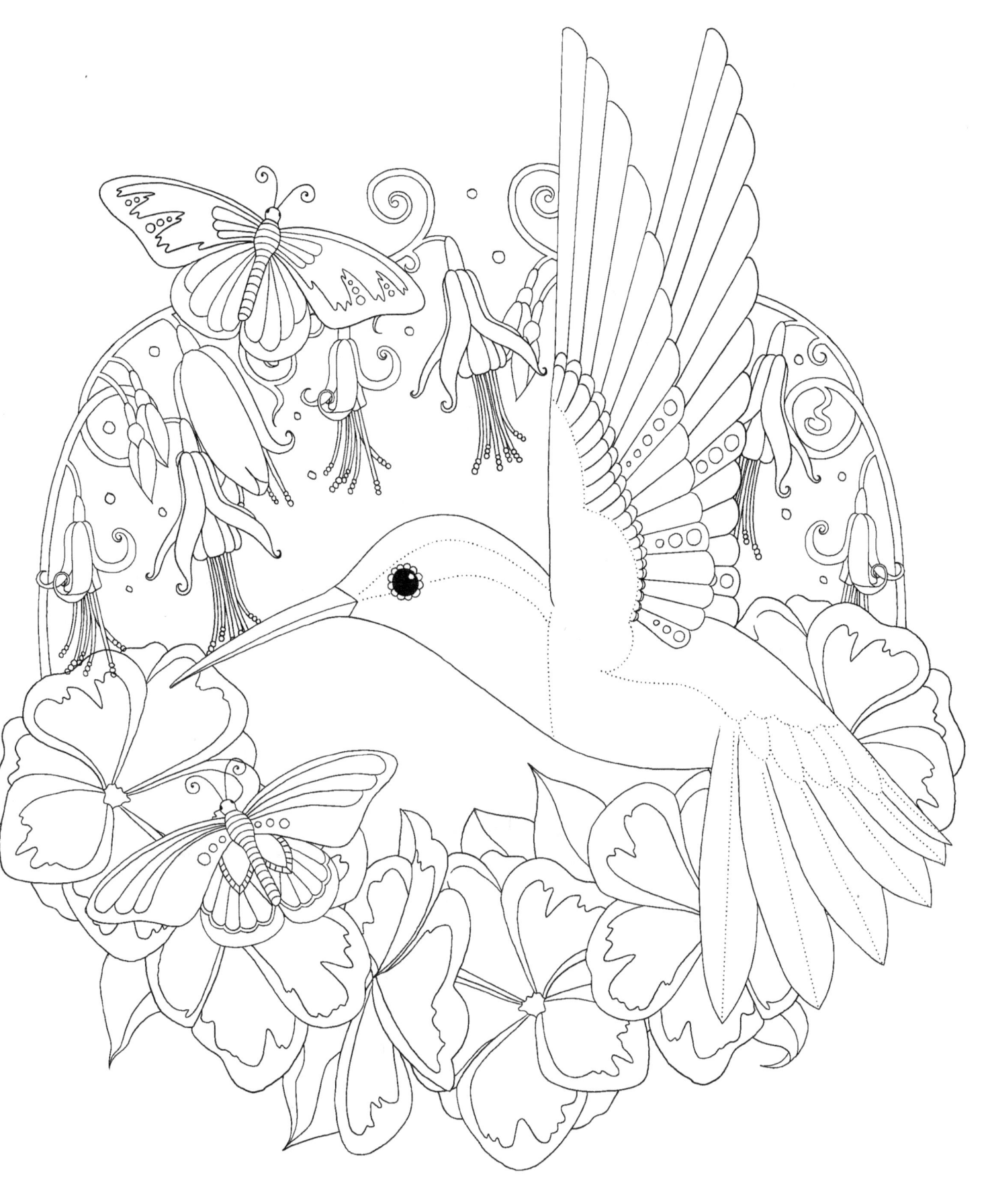

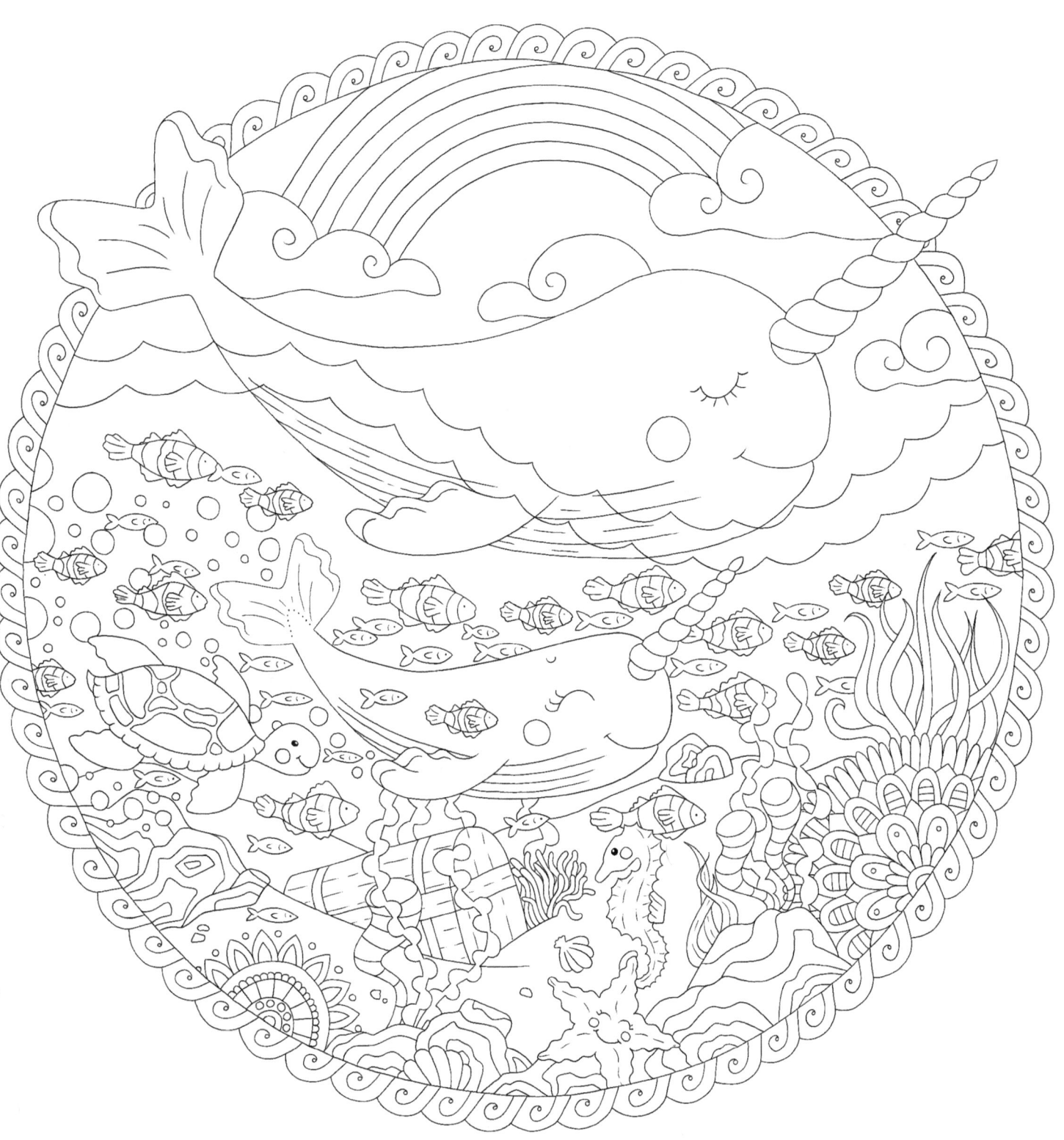

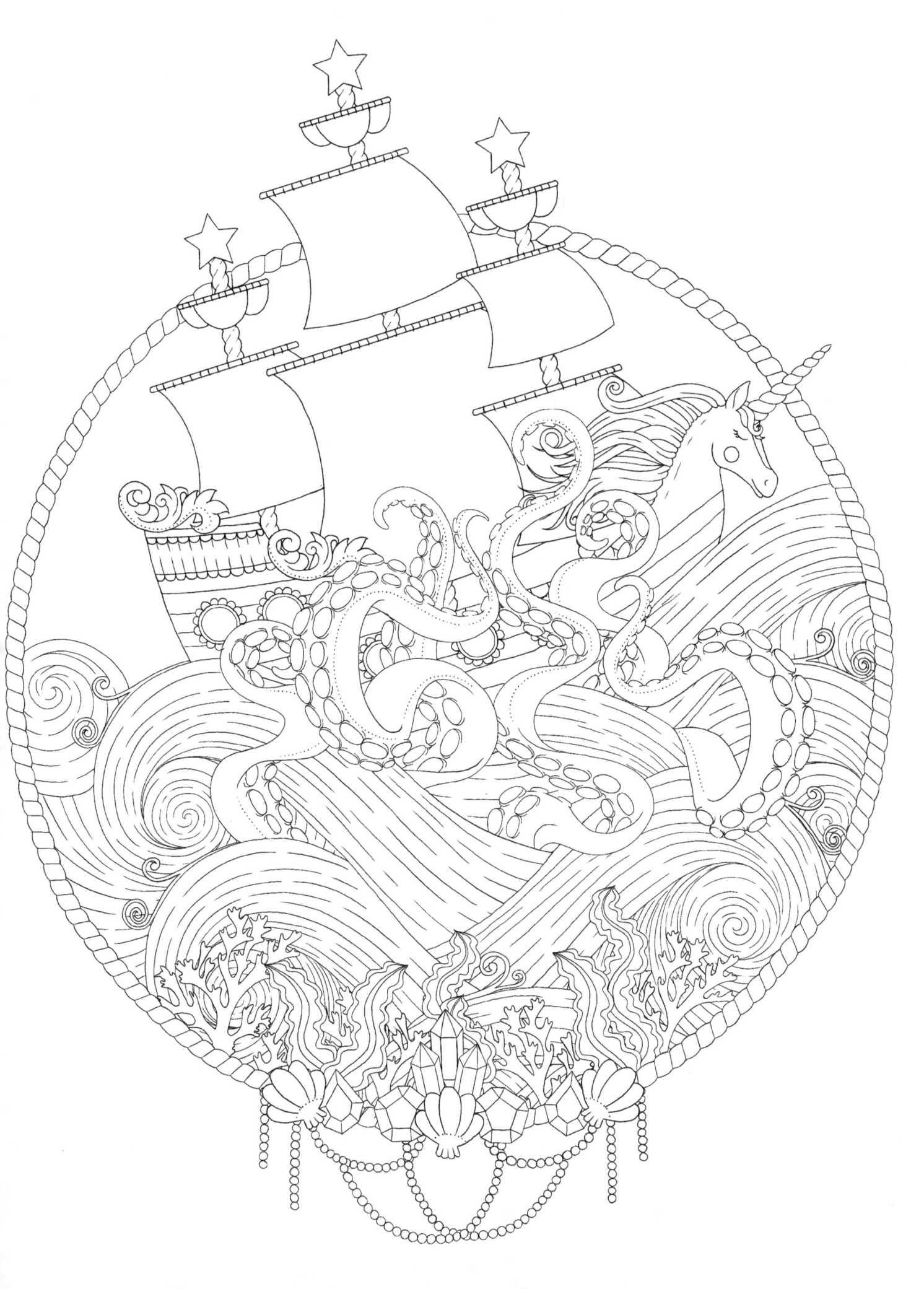

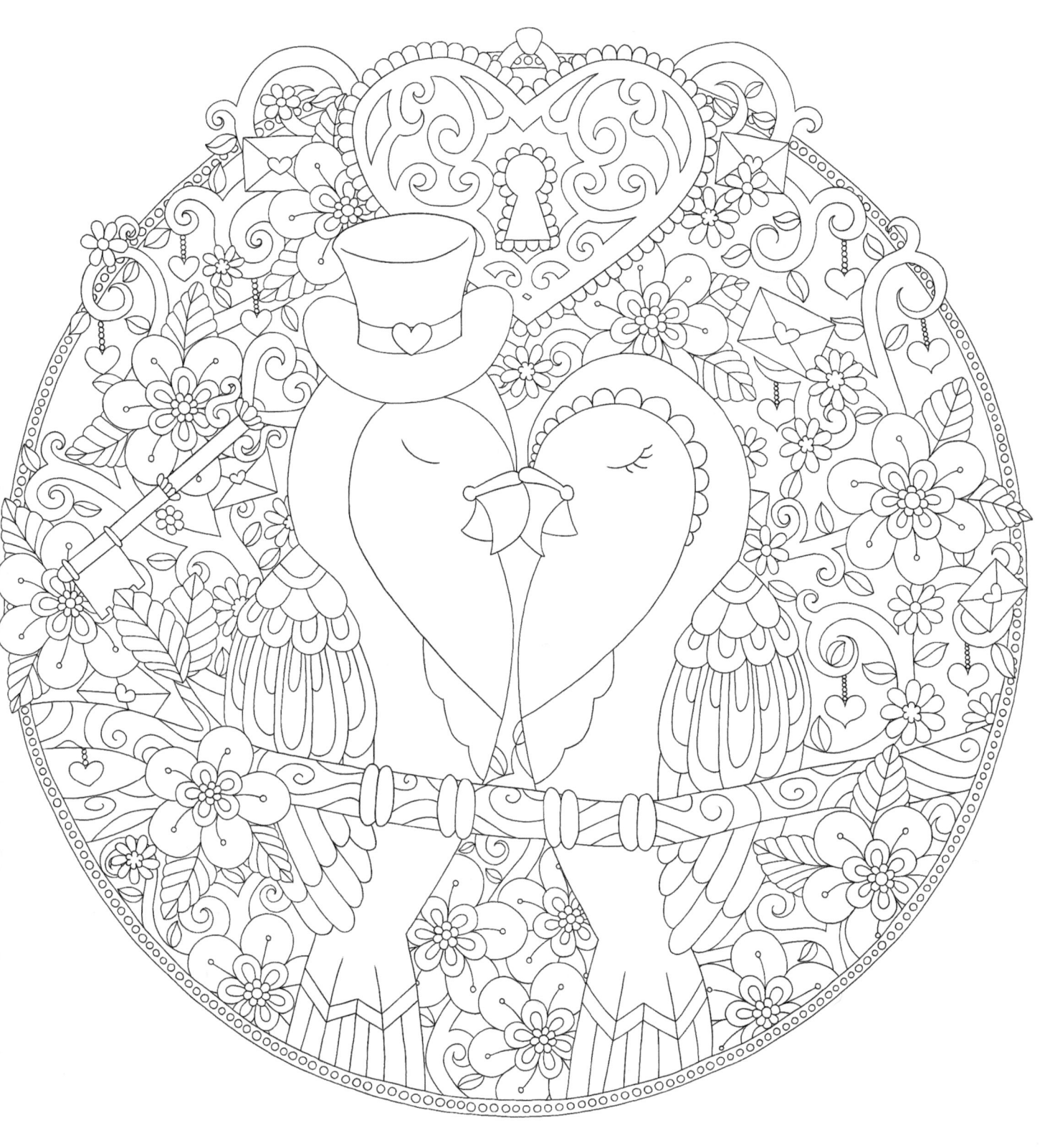

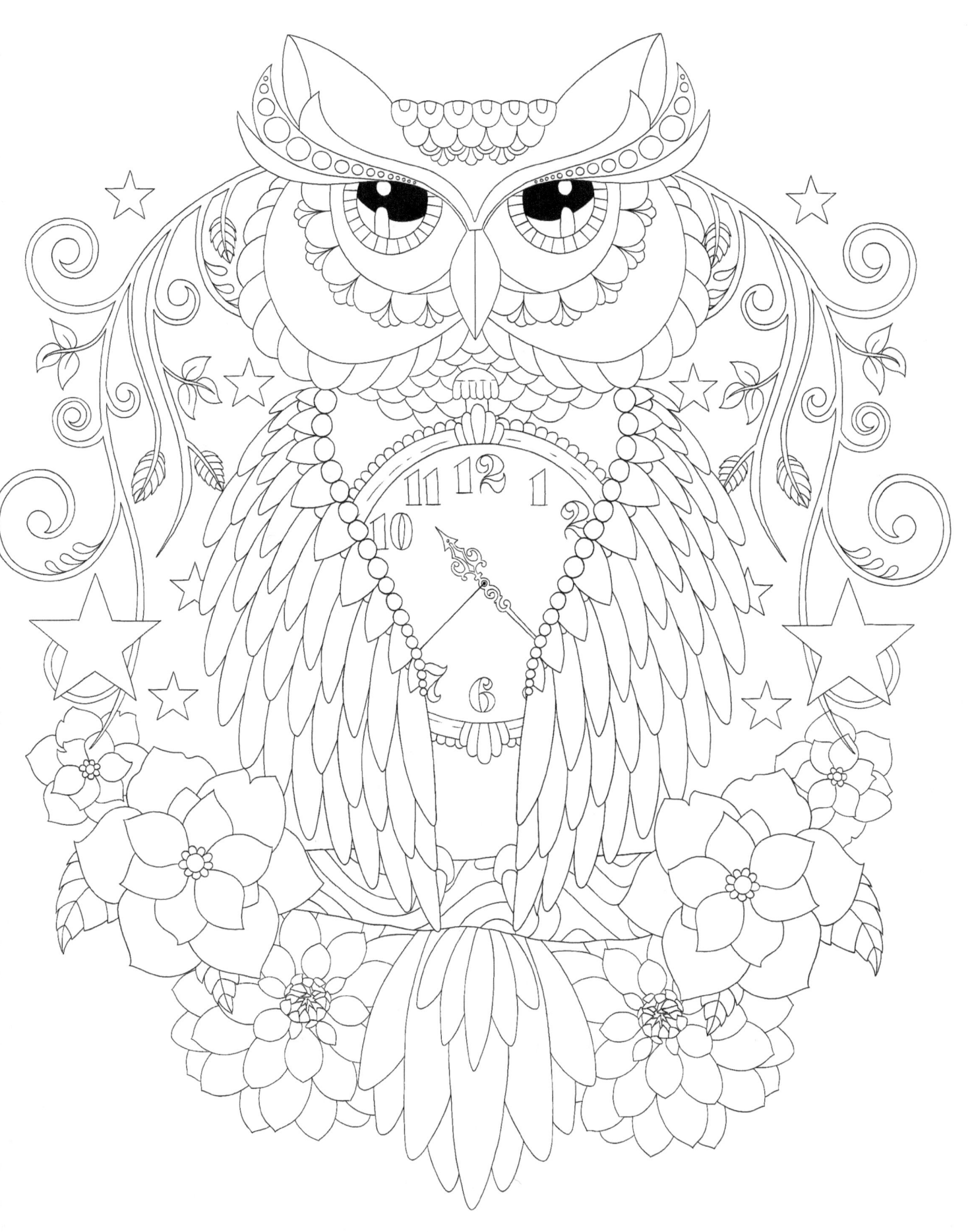

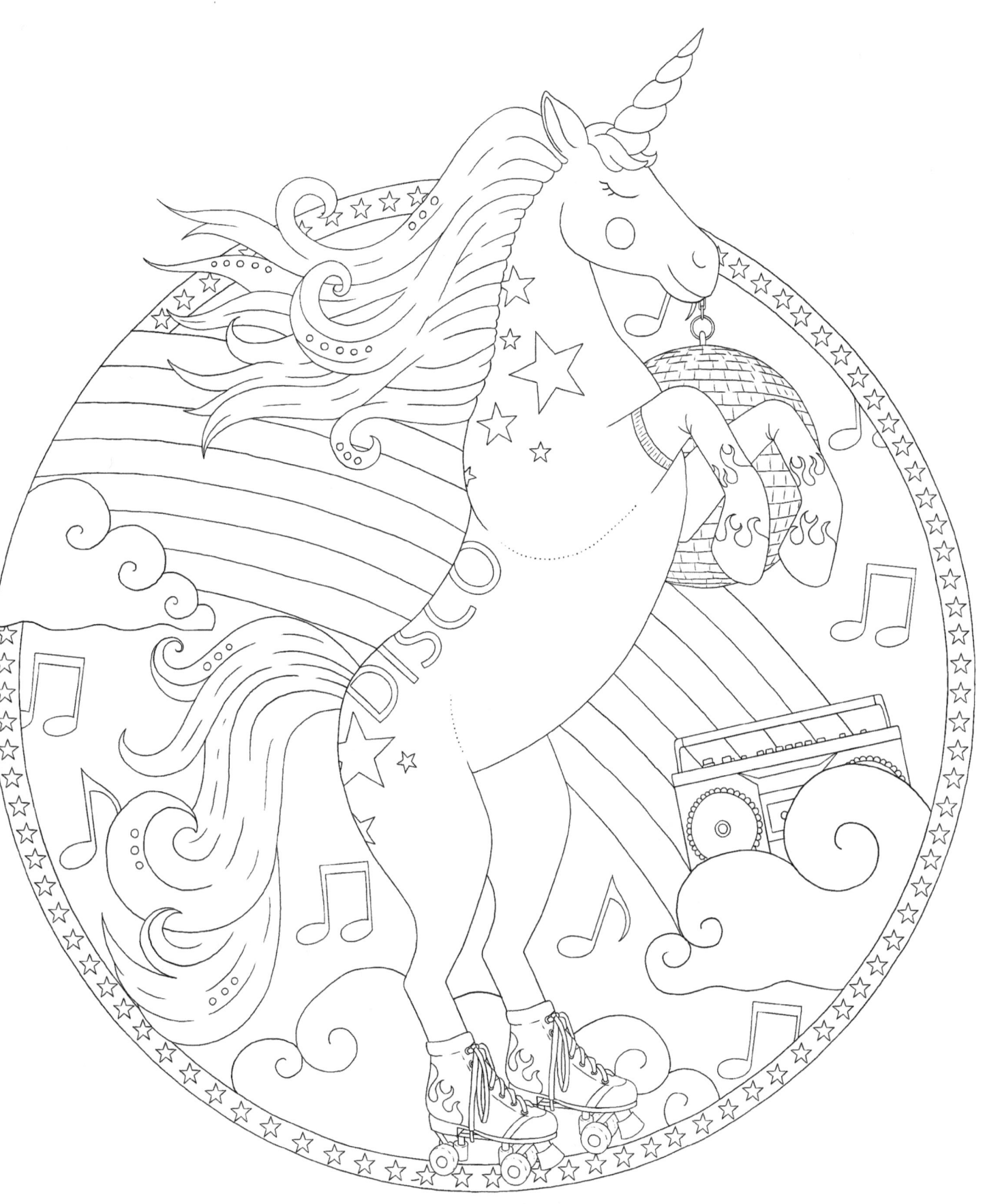

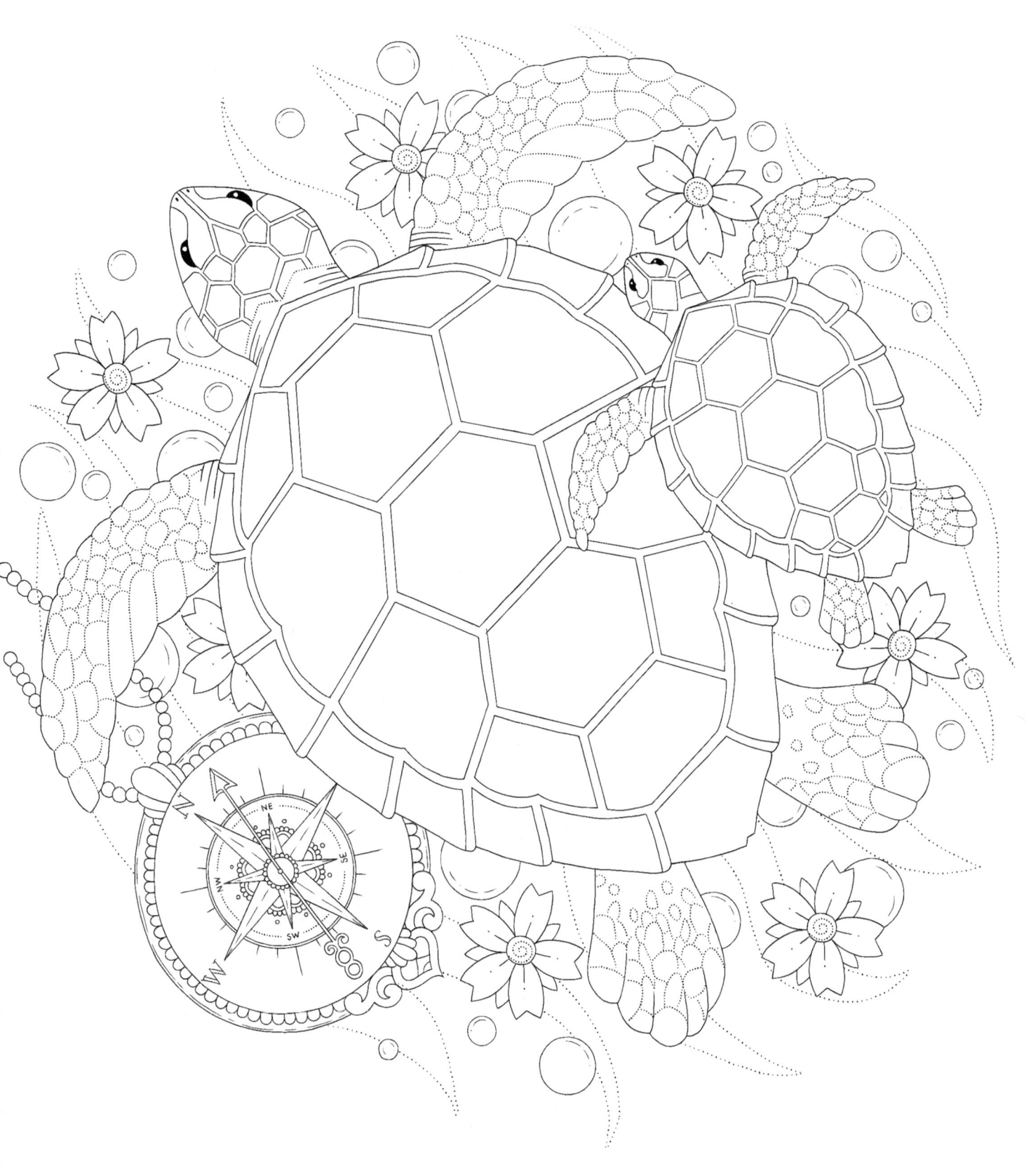

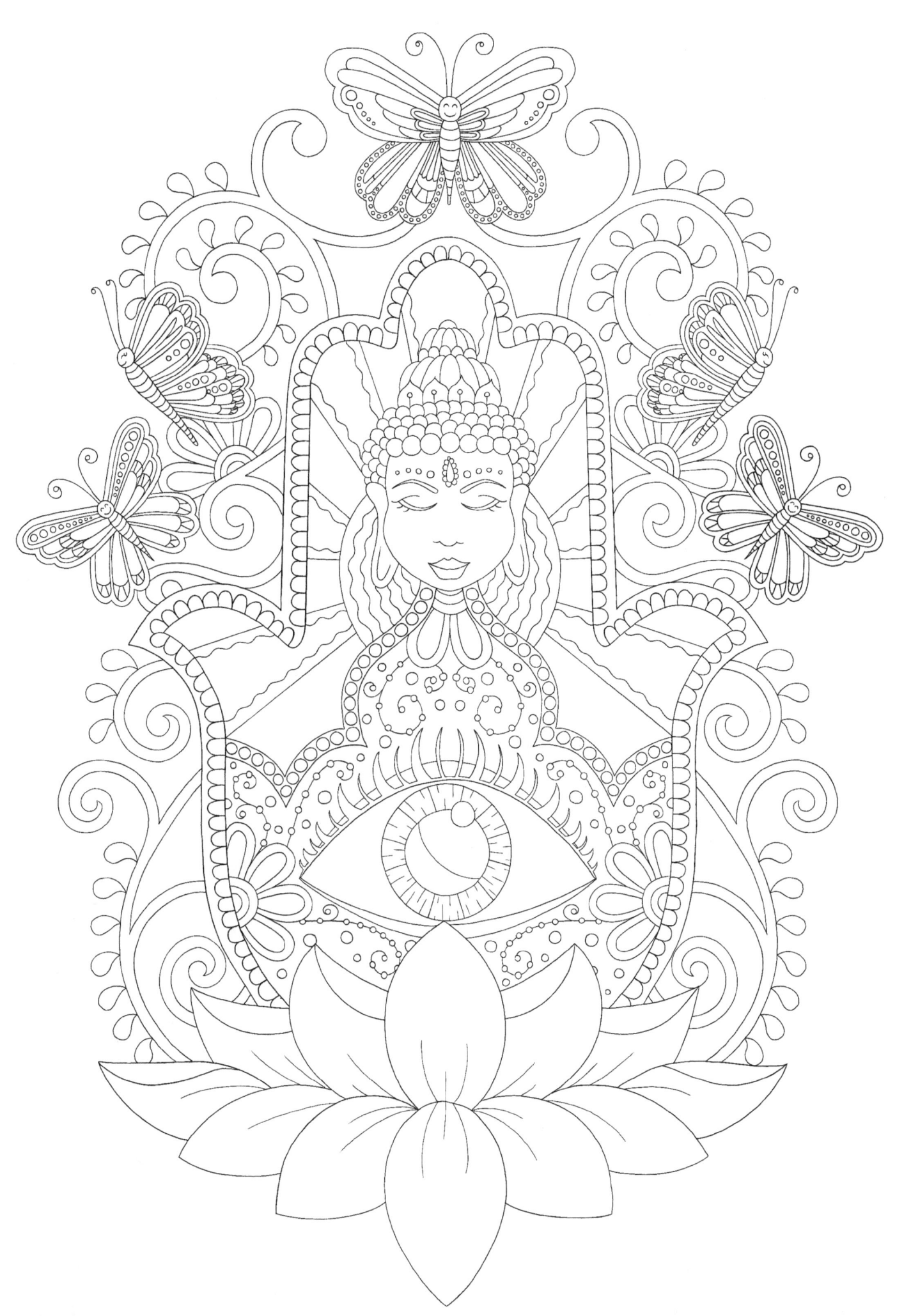

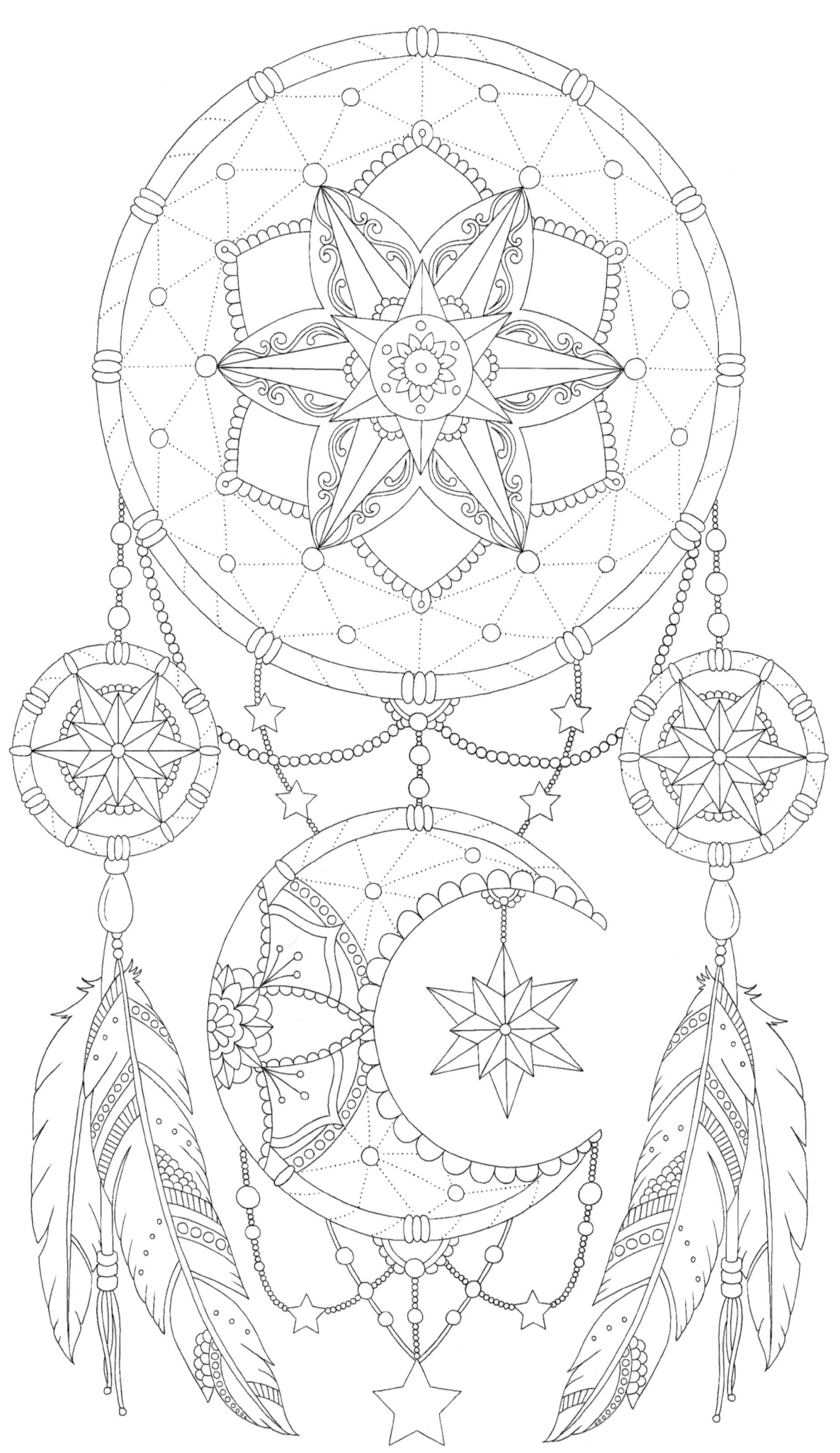

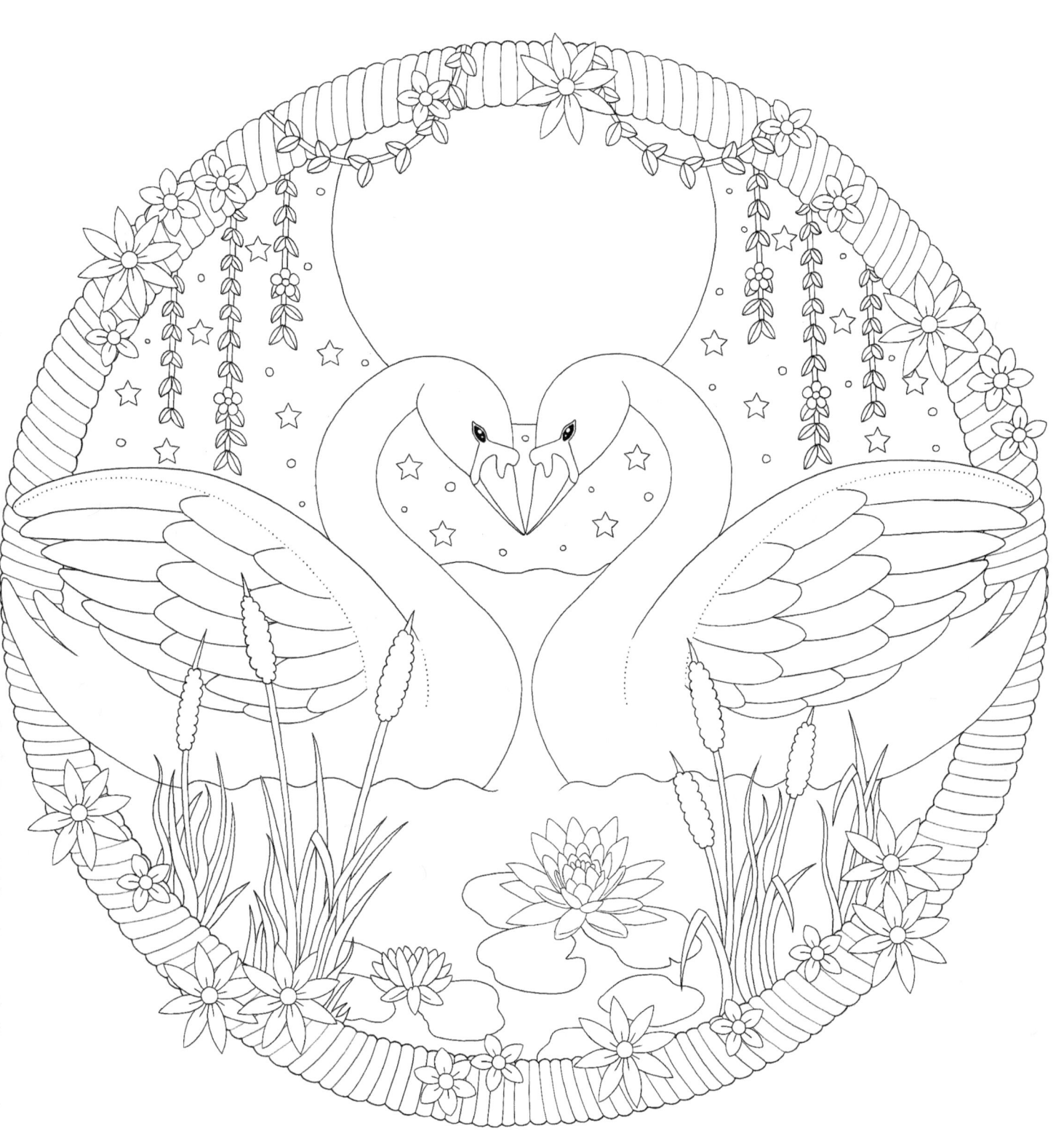

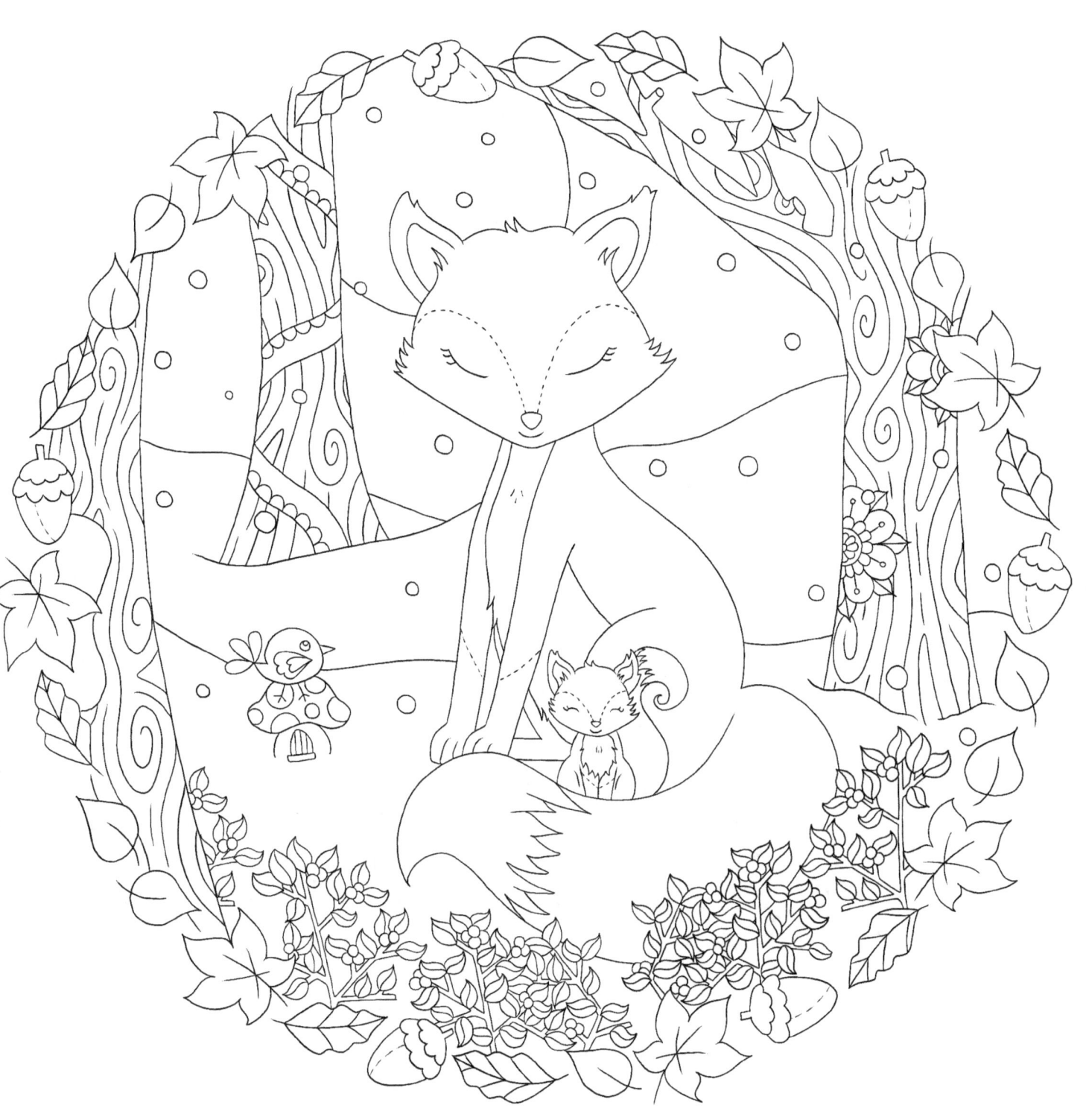

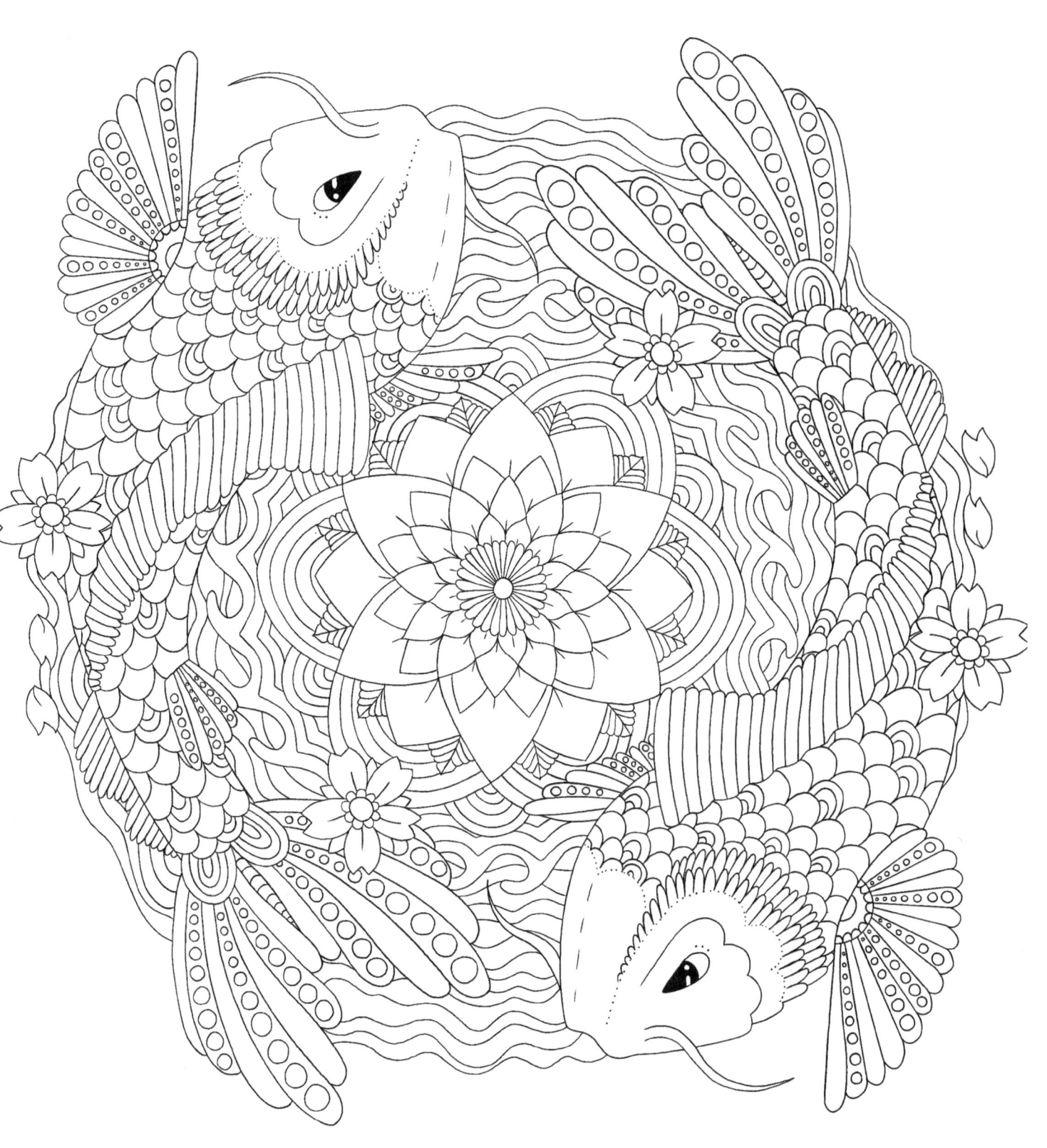

Arctic Animals

Baby Sloths in the Rainforest

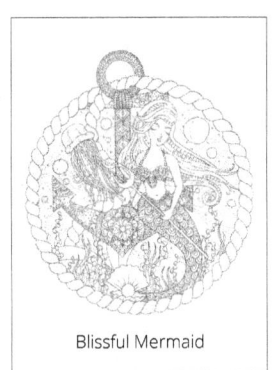
Blissful Mermaid

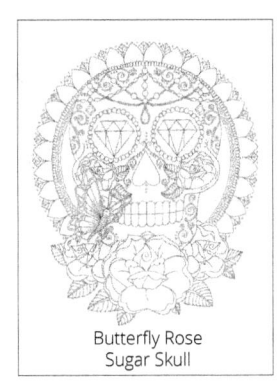
Butterfly Rose Sugar Skull

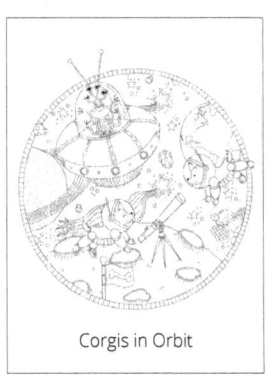
Corgis in Orbit

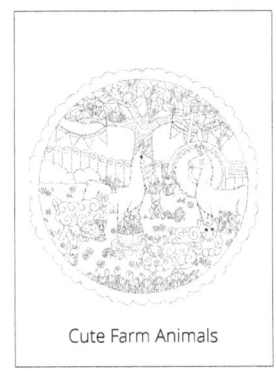
Cute Farm Animals

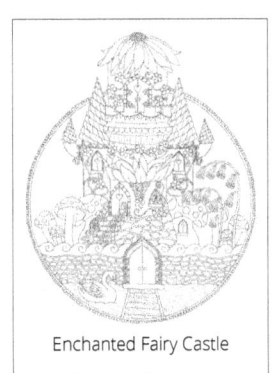
Enchanted Fairy Castle

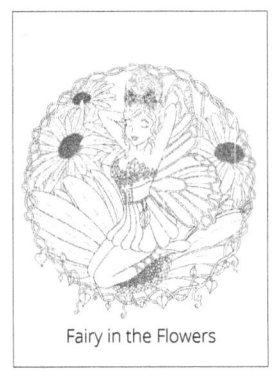
Fairy in the Flowers

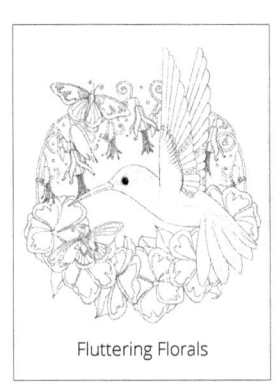
Fluttering Florals

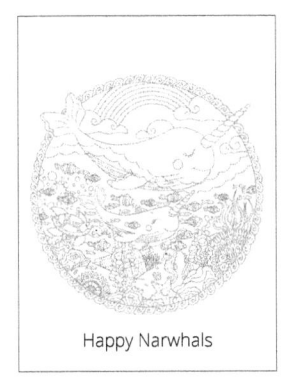
Happy Narwhals

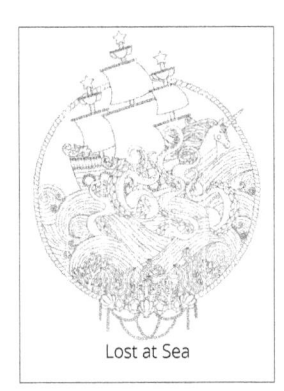
Lost at Sea

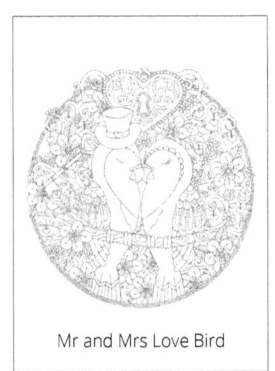
Mr and Mrs Love Bird

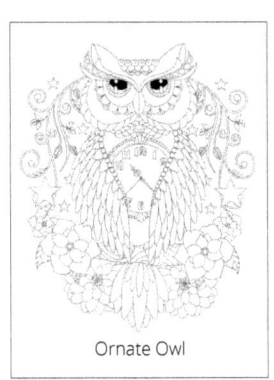
Ornate Owl

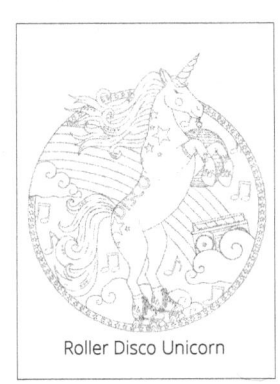
Roller Disco Unicorn

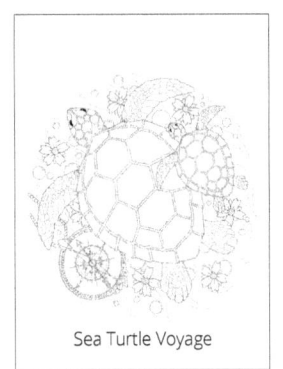
Sea Turtle Voyage

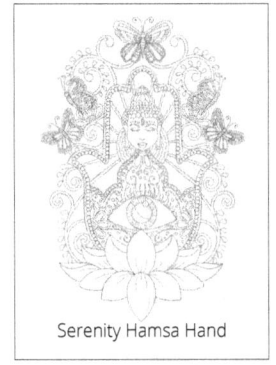
Serenity Hamsa Hand

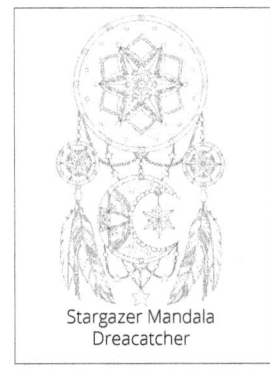
Stargazer Mandala Dreacatcher

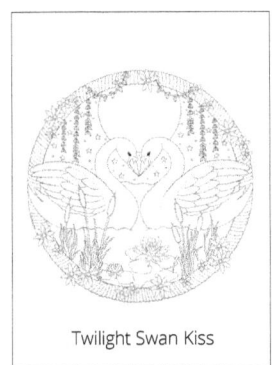
Twilight Swan Kiss

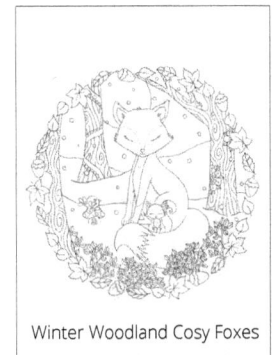
Winter Woodland Cosy Foxes

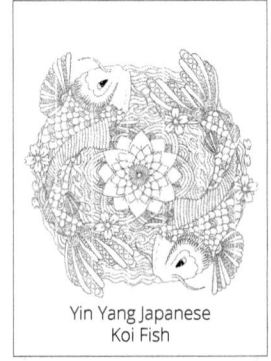
Yin Yang Japanese Koi Fish

Test your tools

Test your tools

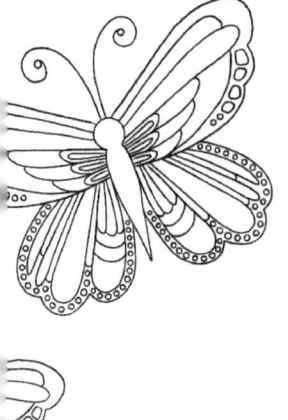

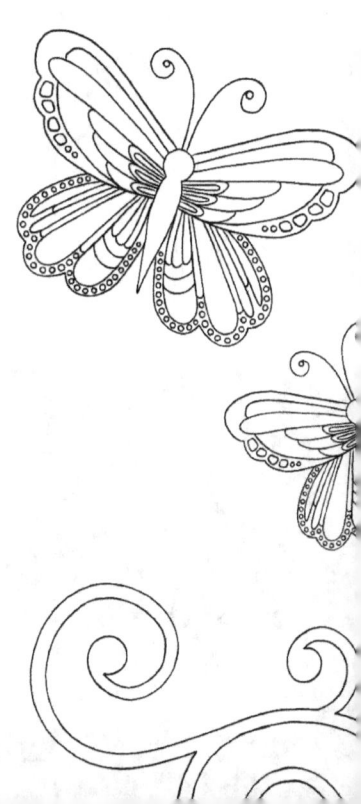

With over 7 years experience in the creative industry as a digital designer, I rediscovered my love for doodling when trying to find a hobby that would exercise my creative skills, outside of the world of web design and branding.

Drawing was my favourite thing to do as a kid, so naturally, creating cute colouring pages was a very obvious string to add to my bow. For me personally, it's extremely nostalgic.

Bringing my doodles to life in the form of this book has given me endless hours of enjoyment, and I sincerely hope that you can have that same experience when colouring them in.

Fancy getting some freebies?

I'll send you free printable colouring pages, as well tips and tutorials, when you sign up to my email list. No spam ever, just the good stuff.

Sign up at www.foxdesignden.com

 facebook.com/foxdesignbristol

 twitter.com/foxdesignden

 pinterest.co.uk/foxdesignden

 instagram.com/foxdesignden

www.ingramcontent.com/pod-product-compliance
Lightning Source LLC
Chambersburg PA
CBHW060006230526
45472CB00008B/1969